tierney gearon

alphabet book

a

airplane adventure

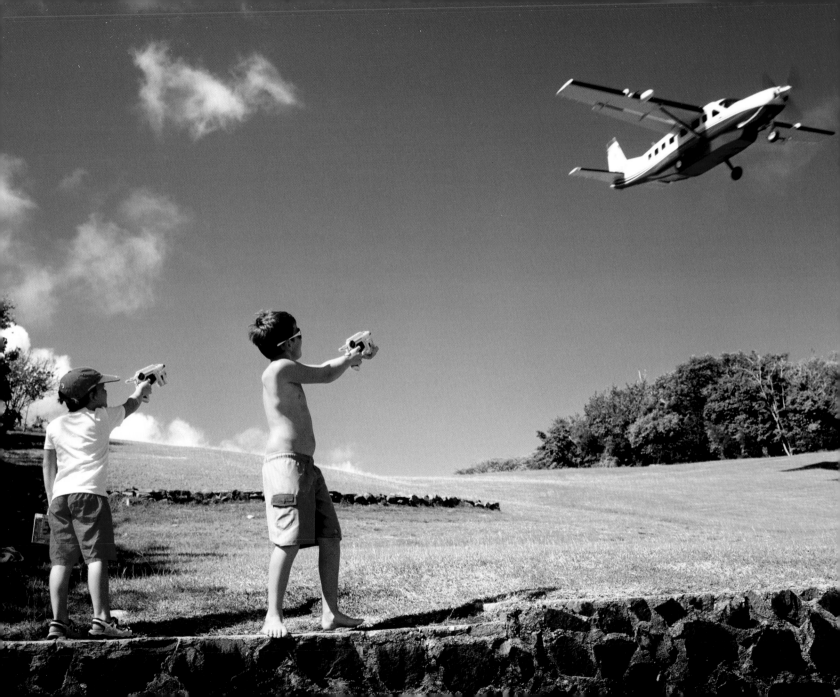

b

bear boy

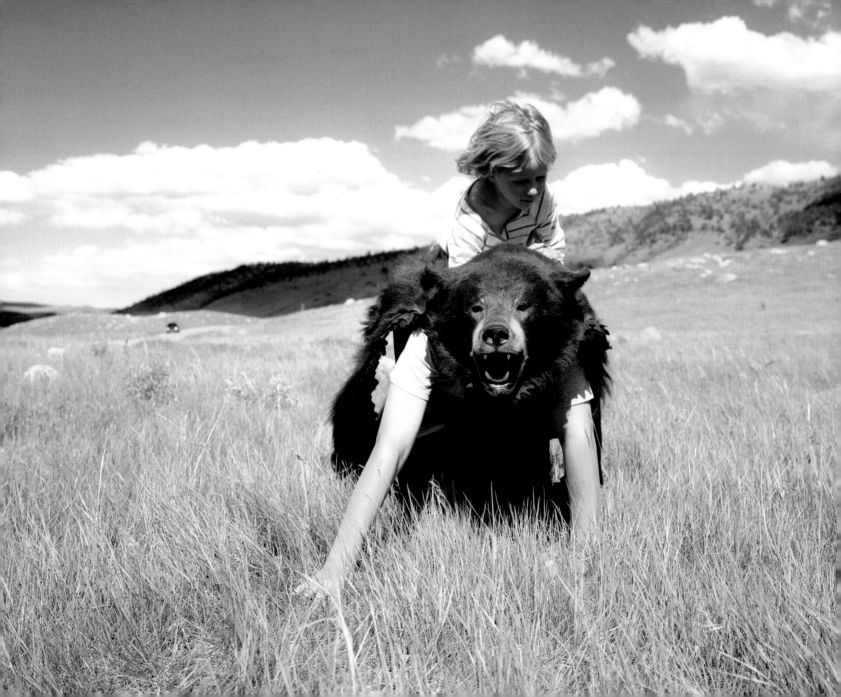

c

clown car

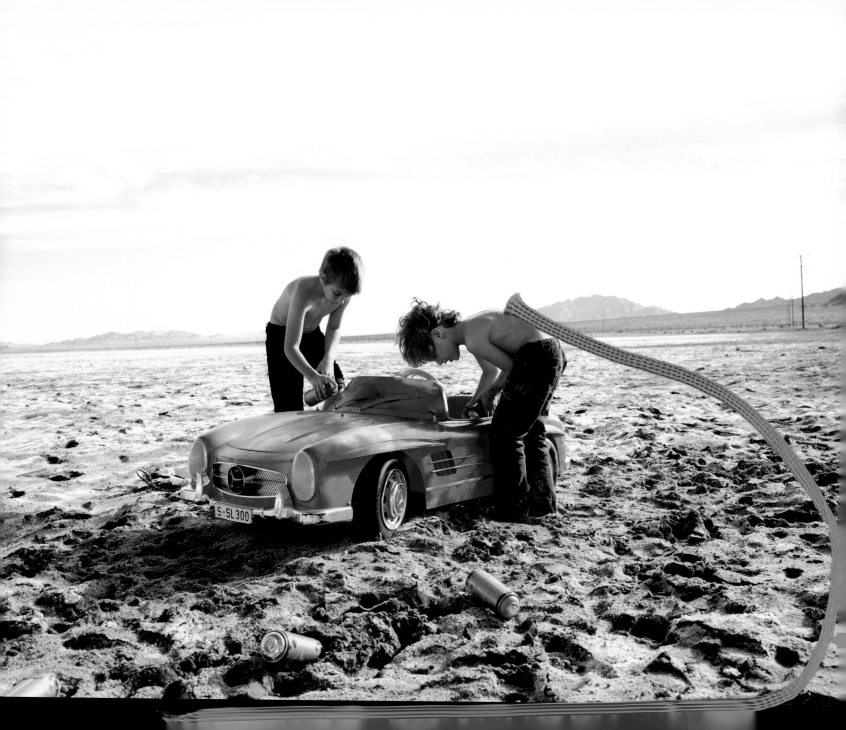

d

doubtful dangers

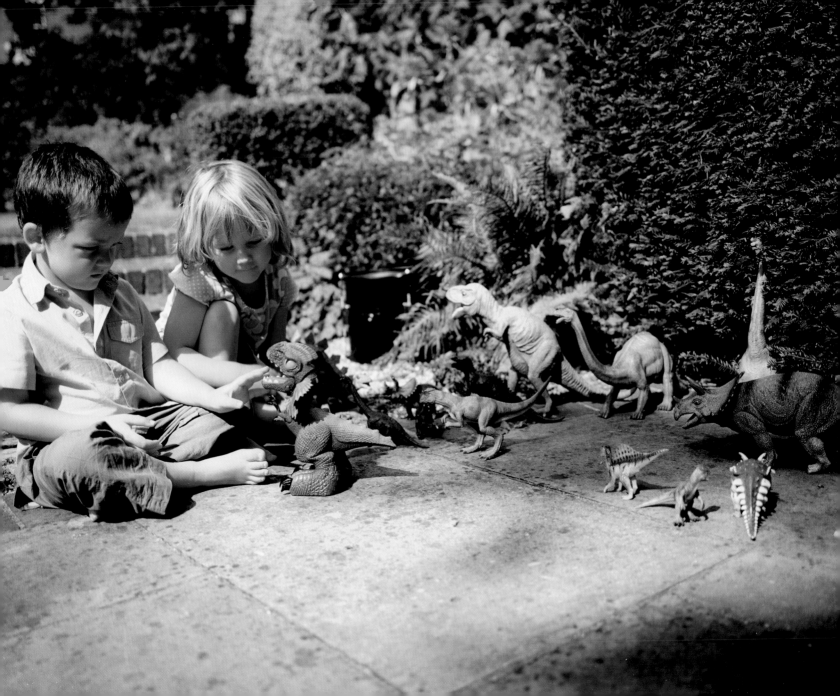

e

eagle eye

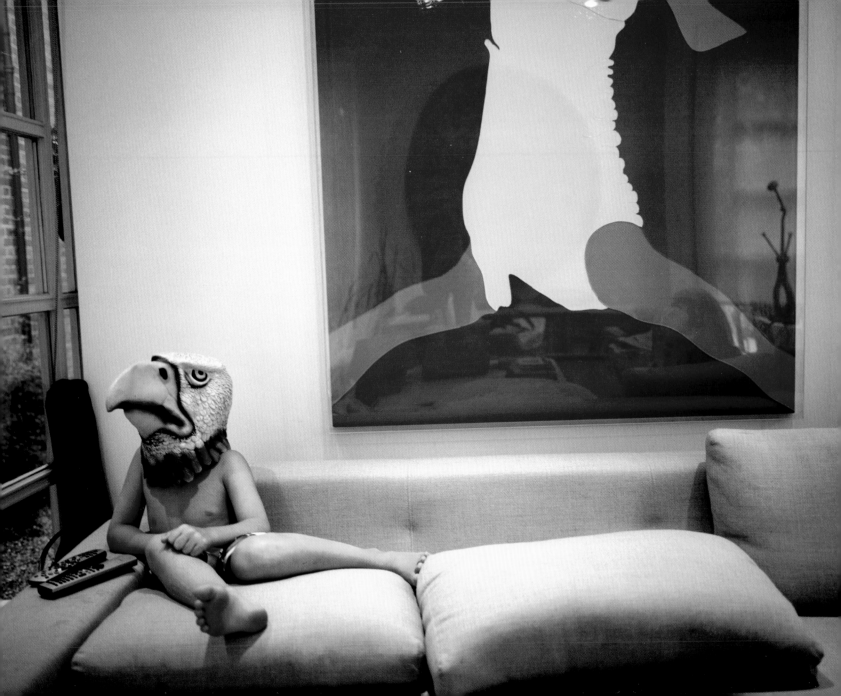

f

forgetful fishing

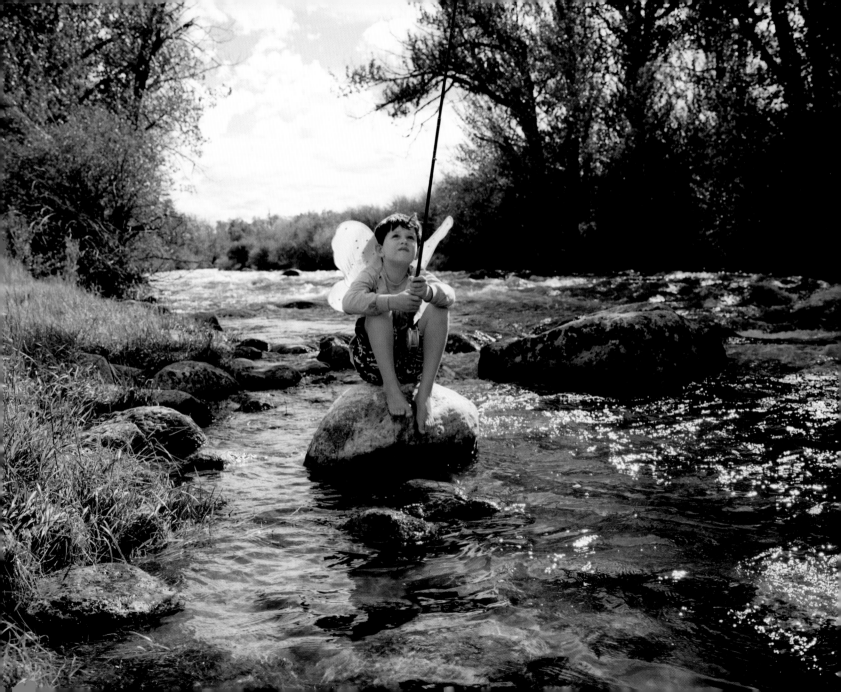

g

grumpy girls

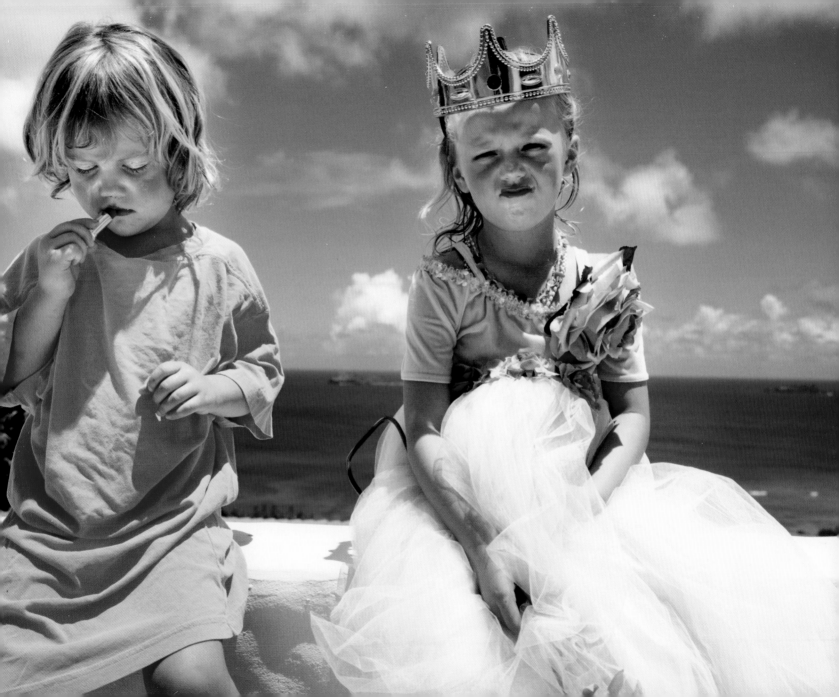

h

hollow house

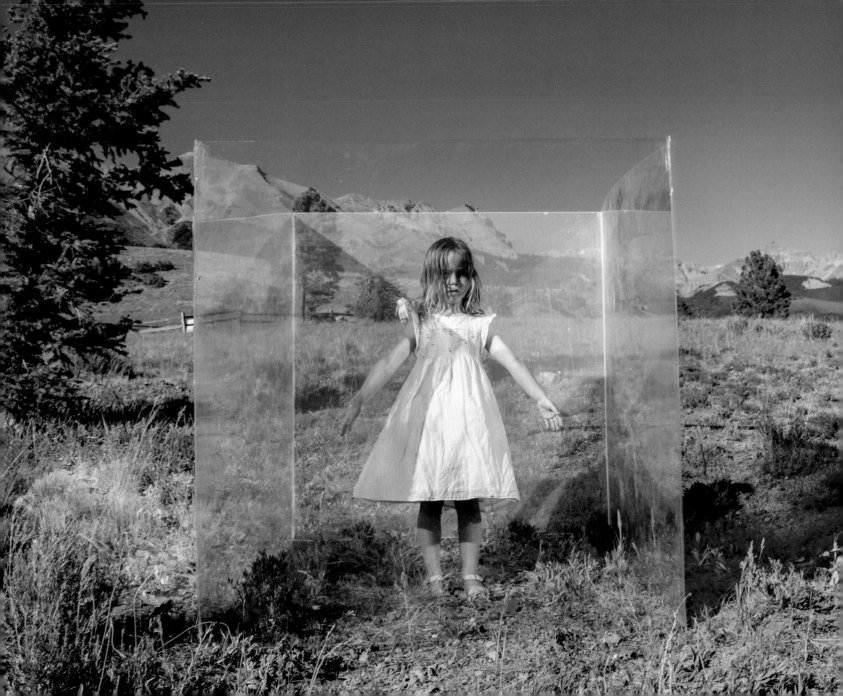

i
instant incognito

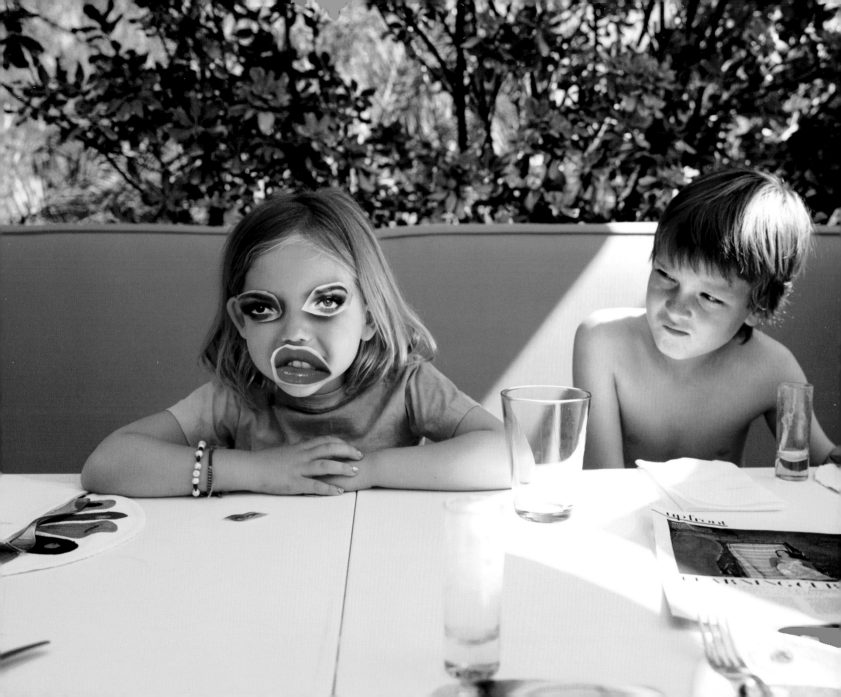

j

jumping joy

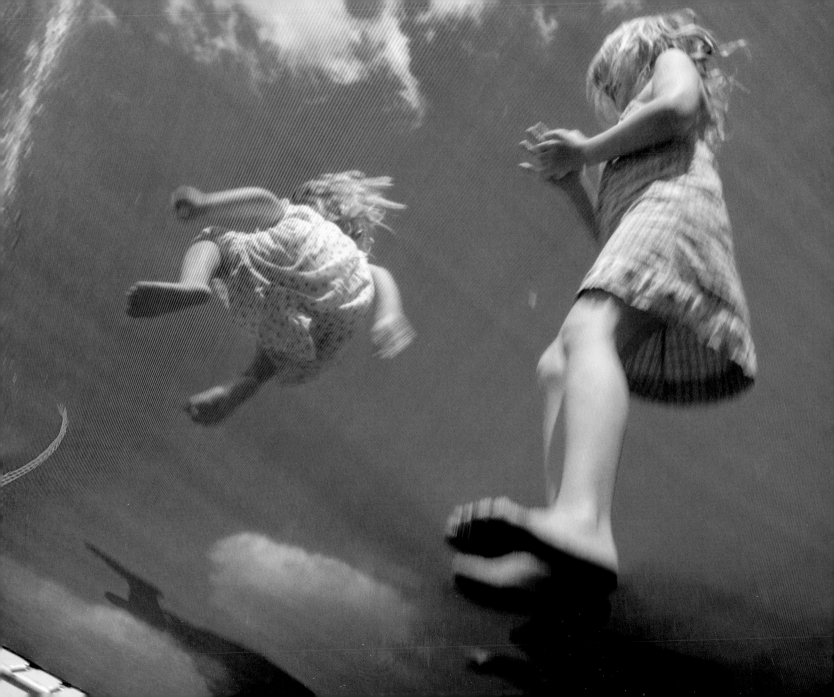

k

kissing kids

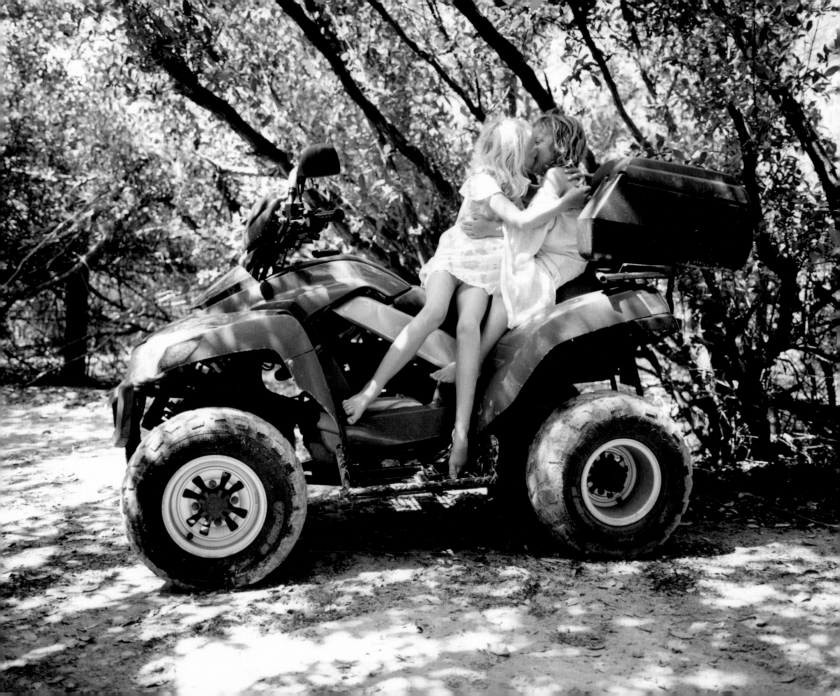

long leg lollipops

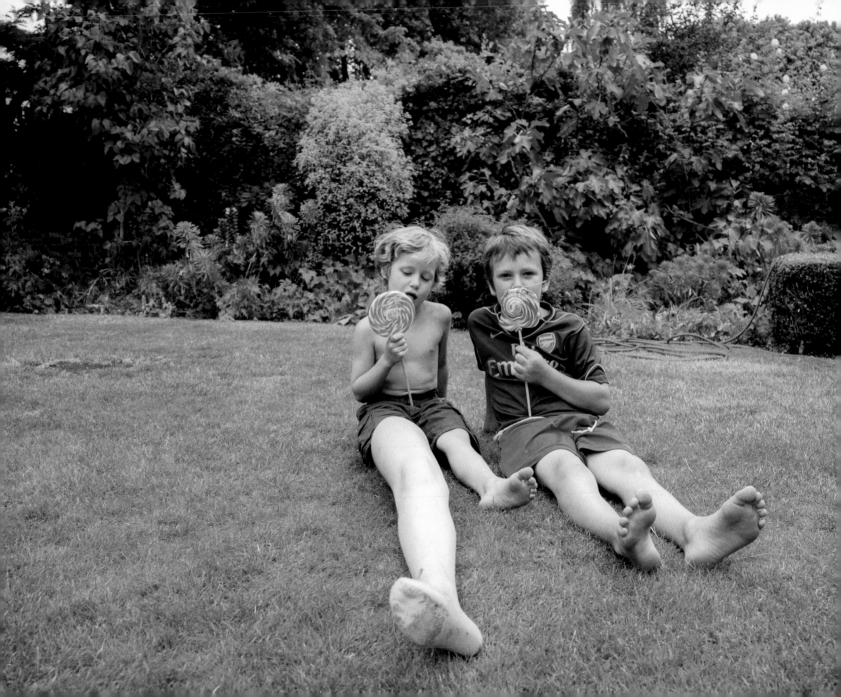

mister mustache

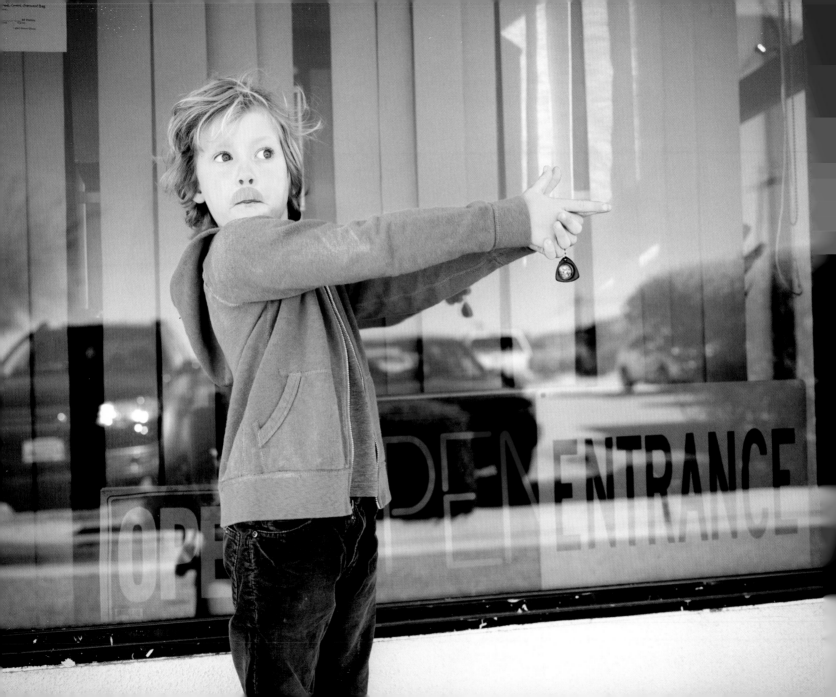

n

naughty nurse

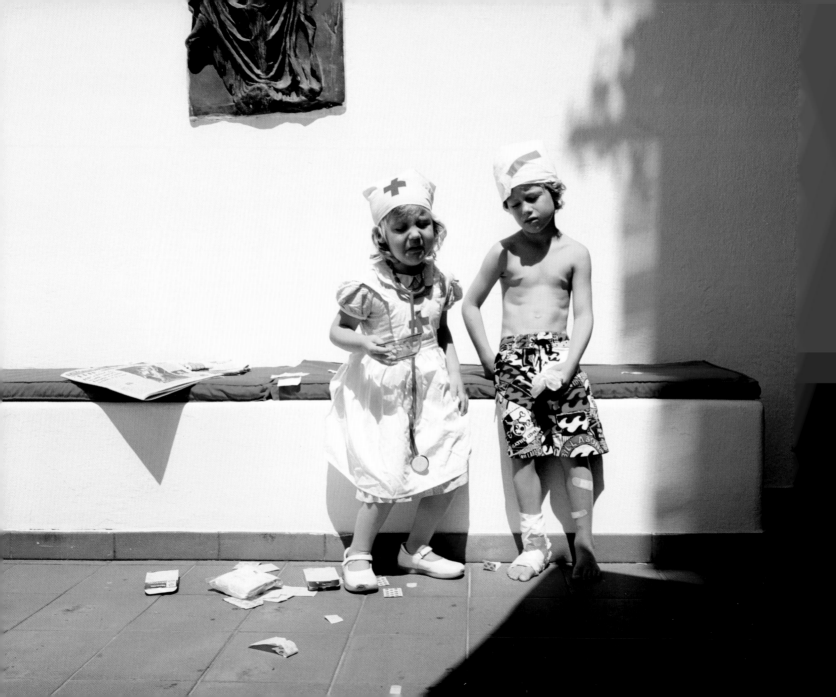

o

obviously old

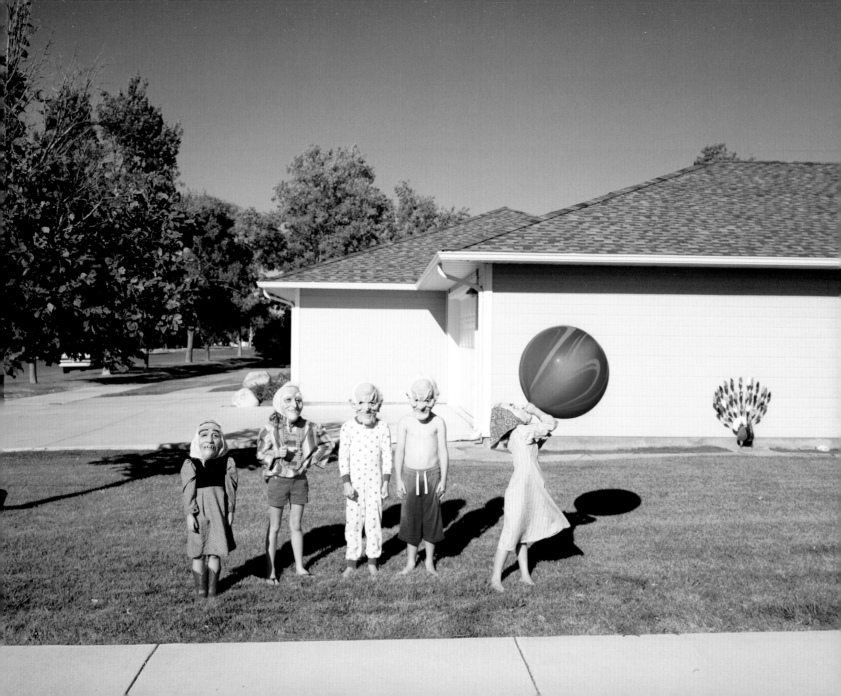

p

private princess

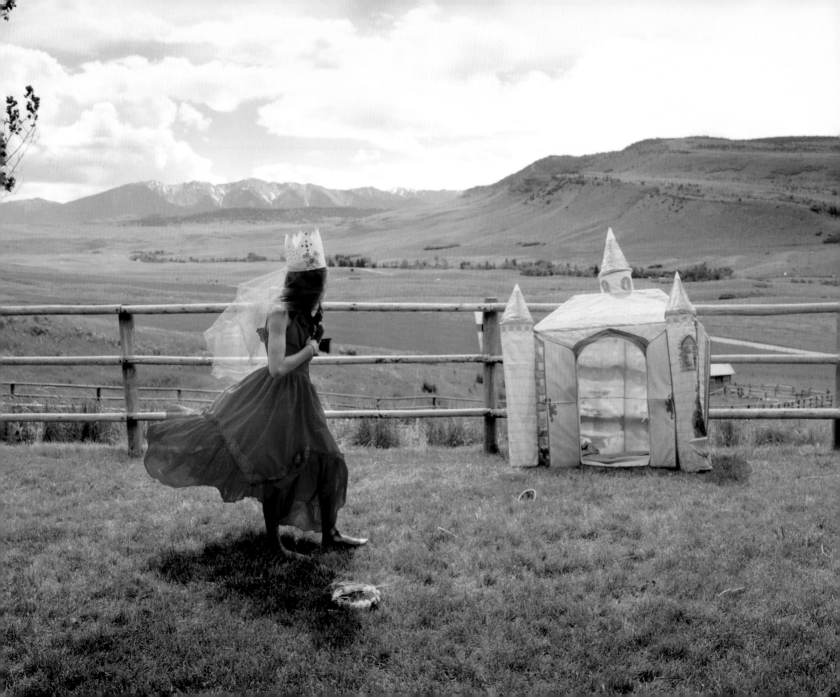

q

quiet quiver

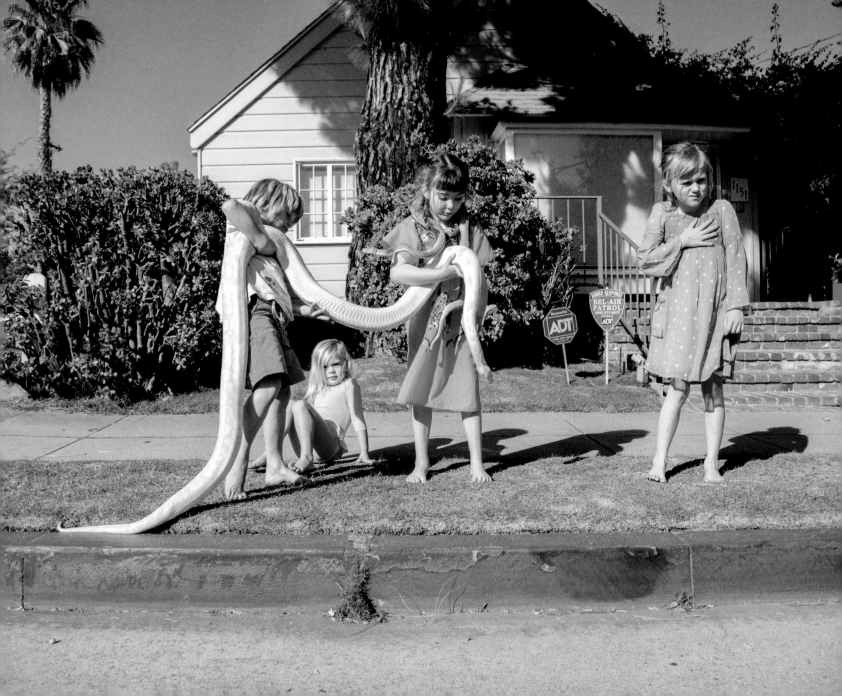

r

rat reading

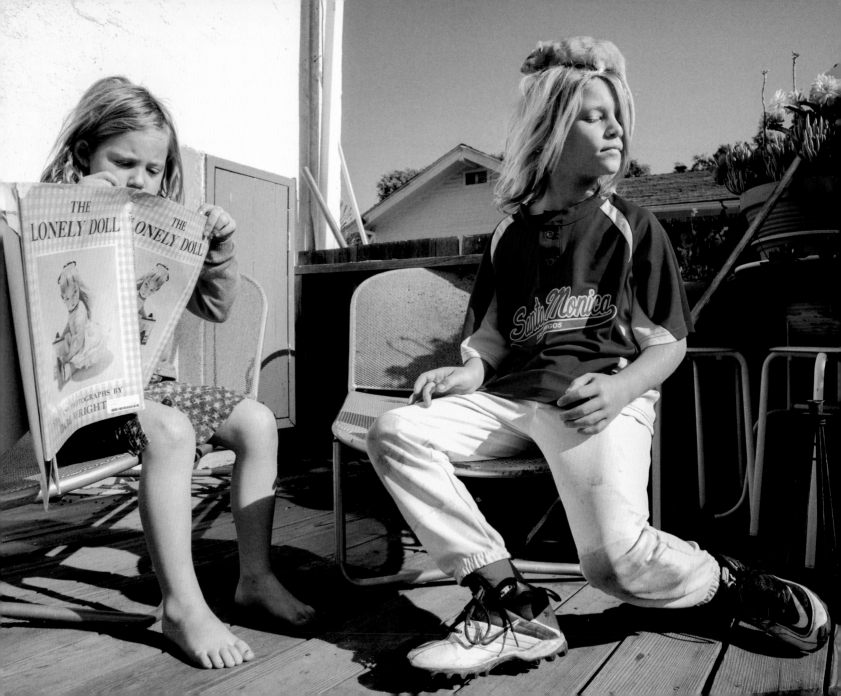

s

sunbeam stones

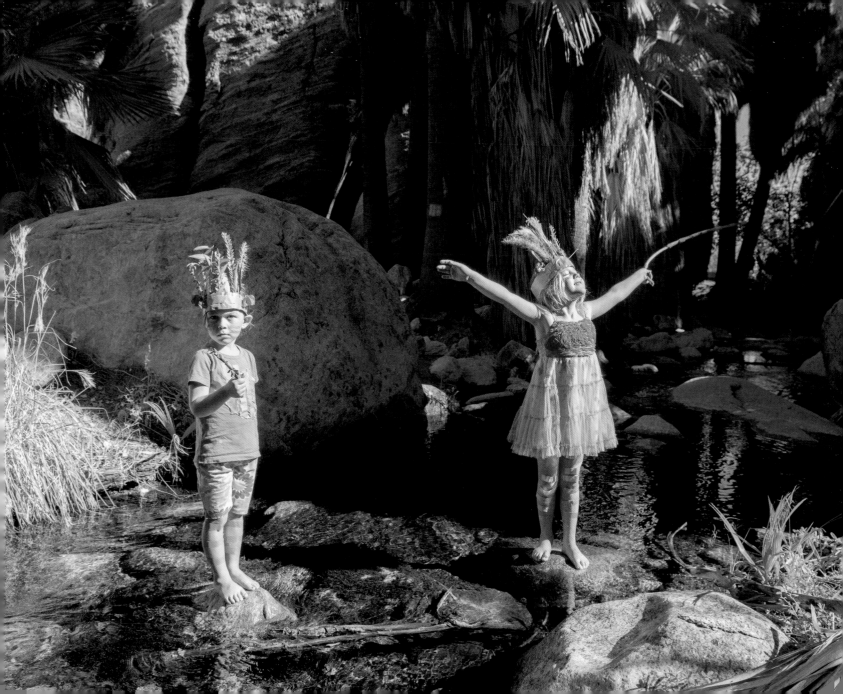

t

tree twins

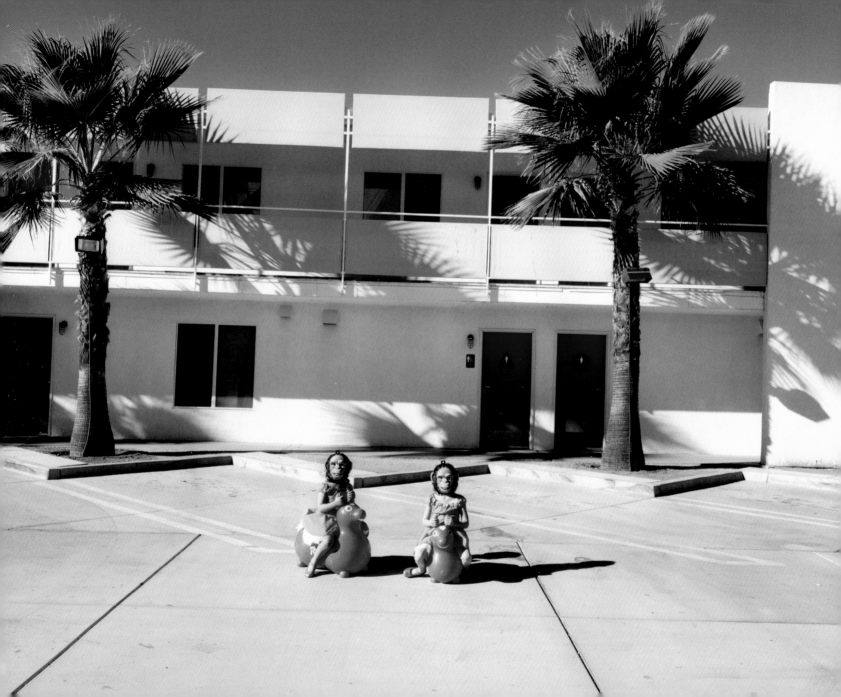

u

ultimate uniform

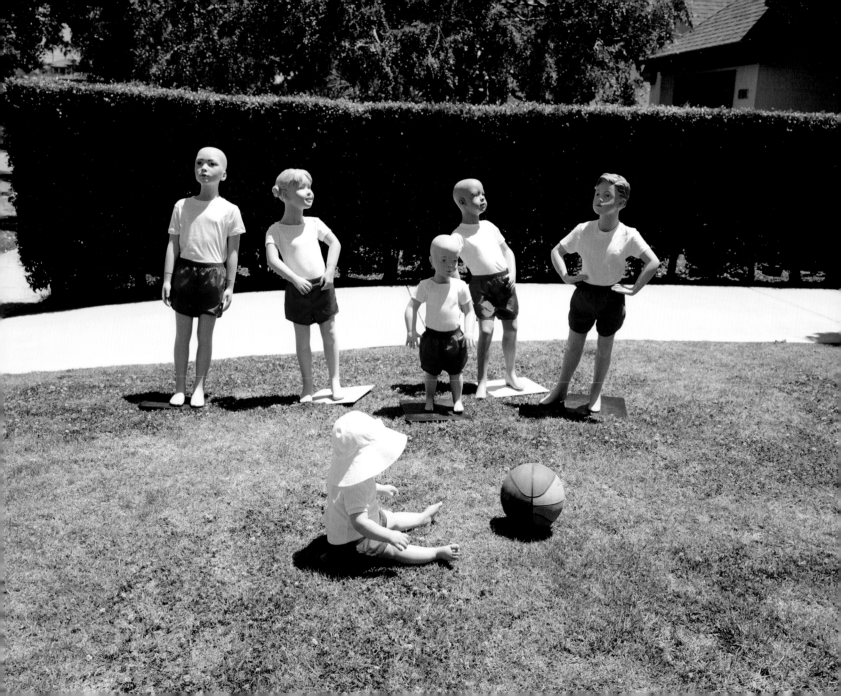

V

vacuum vacation

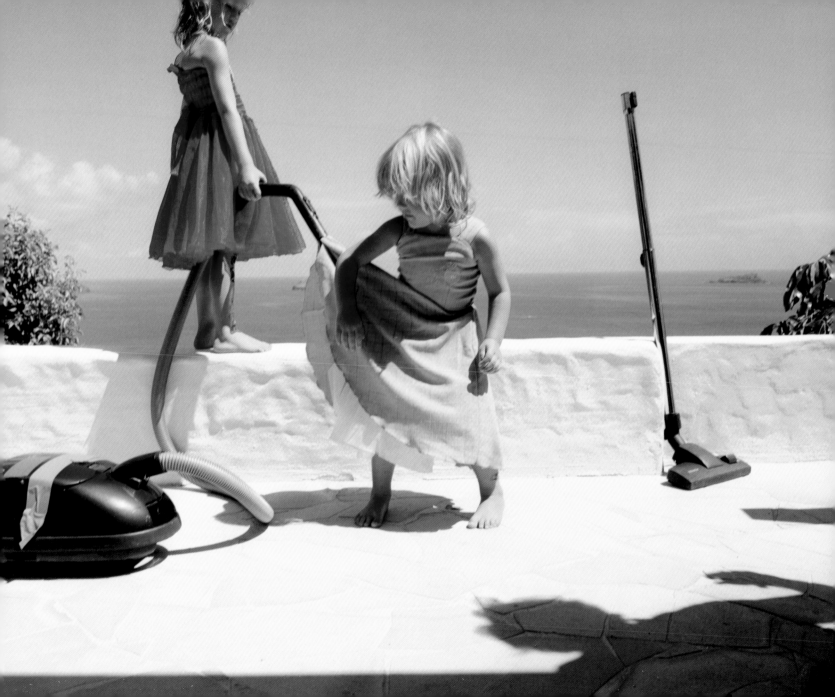

W

wonder wig

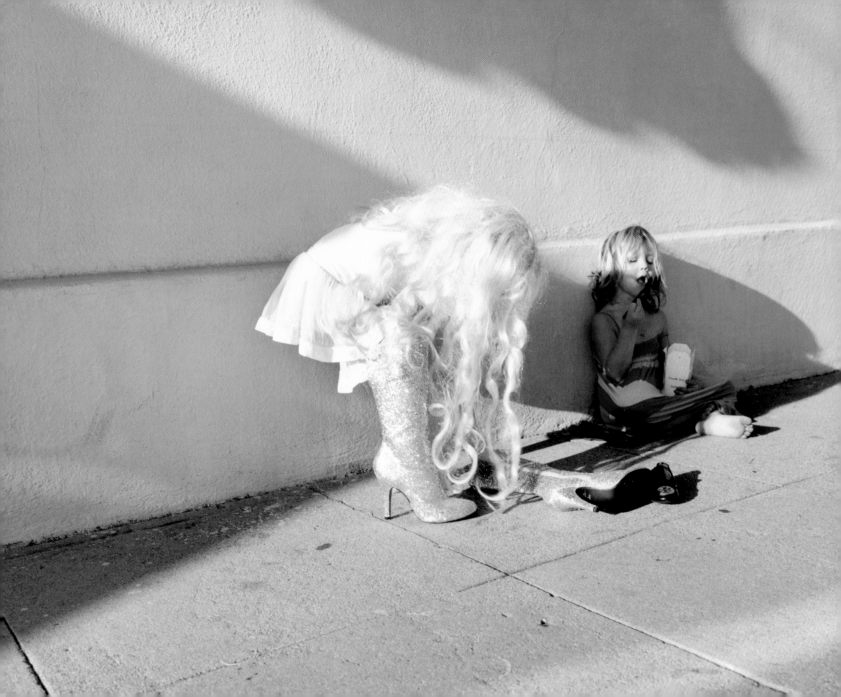

X

xmas xing

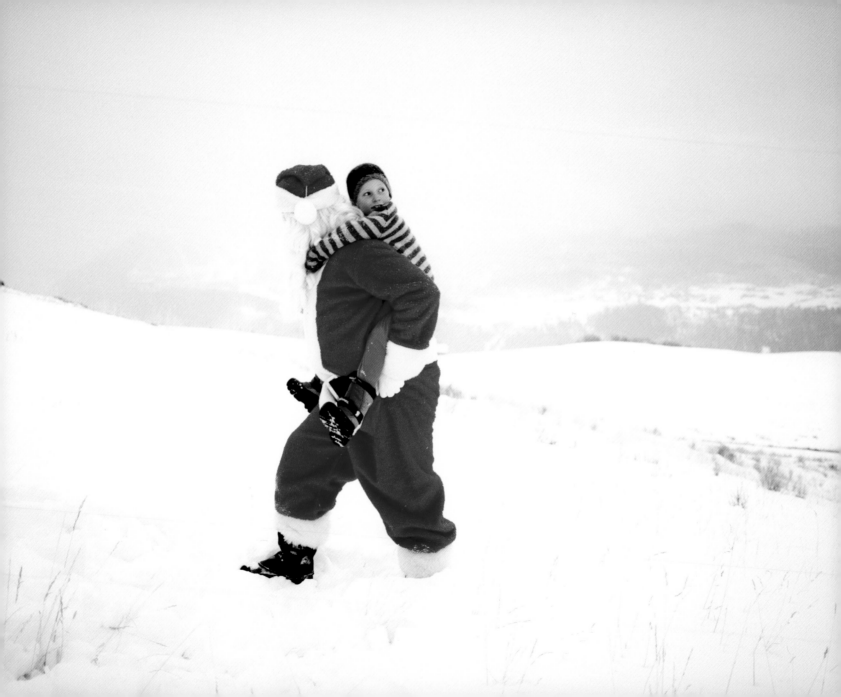

y

yelling yellow

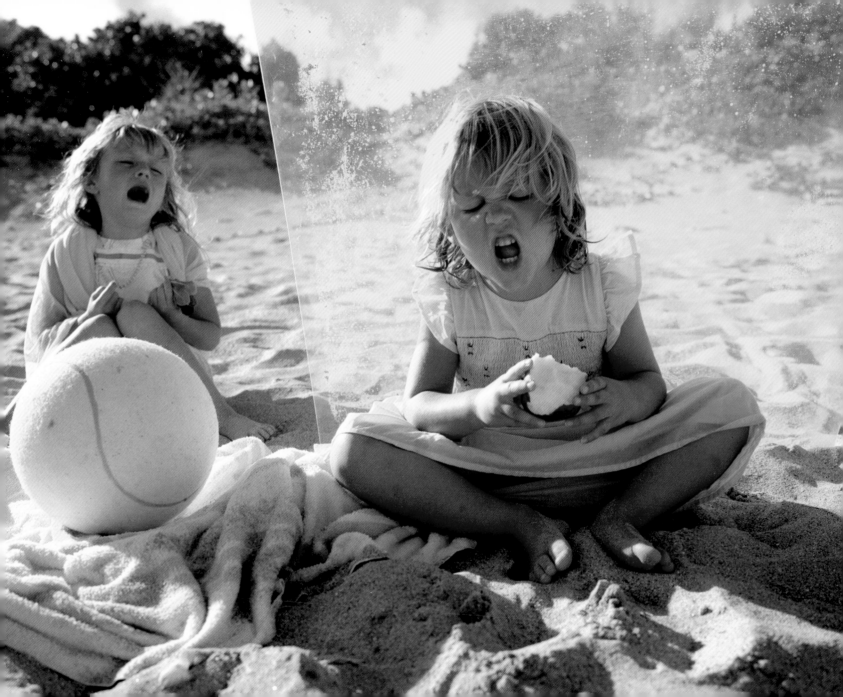

z

zany zeal

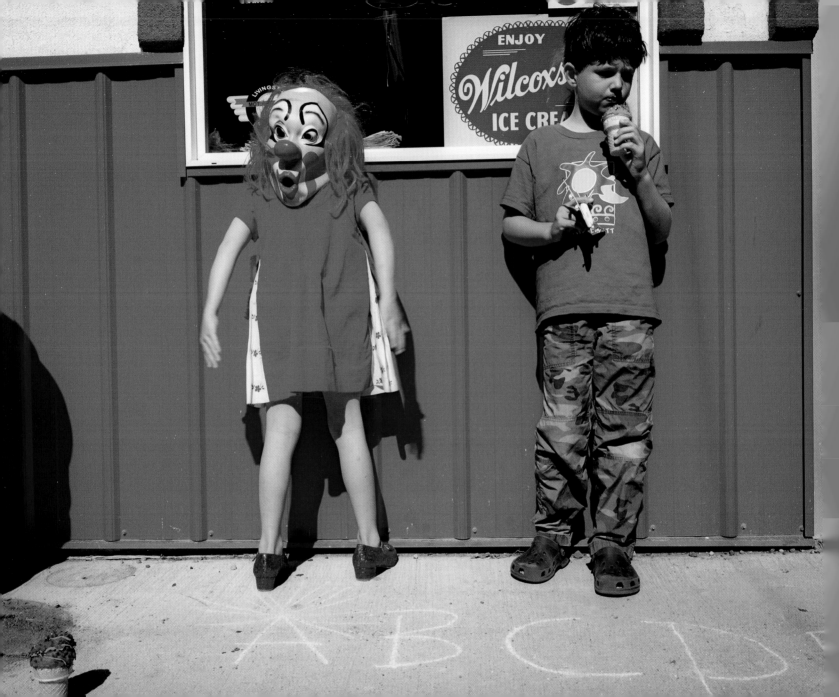

Tierney Gearon - Alphabet Book

This book is a friend and family collaboration all
of the images were taken from July 2010 - July 2013.

Thanks Alexander, Bailey, Charlotte, Christie, Fiona, Grace, Izzy,
Joe, Levi, Lindy, Lucas, Mia, Sky, Sonny, Violet, & Walker.

© Damiani 2013
© Photographs, Tierney Gearon

Photography - Tierney Gearon
Design - Richard Harrington
Image Production - Allan Finamore, Epilogue inc

DAMIANI

Damiani
via Zanardi, 376
40131 Bologna, Italy
t. +39 051 63 56 811
f. +39 051 63 47 188
info@damianieditore.com
www.damianieditore.com

Printed in July 2013 by Grafiche Damiani, Bologna, Italy.

ISBN 978-88-6208-320-1